to the reader

They say that "learning begins by imitating," s ___ __ ___ .led this book
with a lot of illustrations that you can draw by ___ ___. The accompany-
ing sketchbook is the perfect place to begin that process. You will find a
companion page in the sketchbook for each theme. There, you will find
a prompt and some partial drawings or details for inspiration, starting
with a fun collection of happy people, moving on to cute animals, and
lastly we will draw plants and small creatures.

Take your time, look at each illustration one by one, then choose one you
like. You can try tracing first, or draw one yourself in the sketchbook.
Your drawing doesn't have to turn out just like the example, so don't
worry if it doesn't match. Think about how you would draw the picture
and arrange its parts any which way you choose!

The trick to enjoying illustration is showing your work to other people.
"Don't you think this is cute?" "This is really funny looking, isn't it?" Ask
your family and friends these questions when you share the drawings
in your sketchbook. The more you draw, the more fun illustrating will
become for you, and the more confident you will become with finding
your own style.

Fill your sketchbook at your own pace, when you want, and wherever
you want. Most importantly, have fun filling your sketchbook with lots
of really cute drawings, OK?

Sachiko Umoto

contents

how to enjoy this book

choose one
Look for your favorite character. Ask your friends and family what characters they like.

imitate it
Look at the page on the left and use the guide to casually trace what you see.

modify it
Try changing the expression of your drawing. You can make different poses, or add different colors.

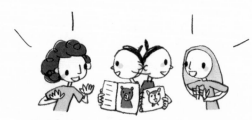

show it
Show your friends and family the pages you have doodled on, or the notebooks and memo pads you have drawn on.

Pencils and Mechanical Pens

If you make a mistake, you can just erase it, so you can draw anything in any way you choose. Apply different pressures to your pencil tip to get a diverse array of lines

Erase with the edges.

Erase a little more than you need to and draw what you lost.

Erasers

Your eraser is a reliable friend you can always count on. Its edges will start to get round as you use it, but that's OK! Simply use a craft knife to carve sharper corners.

The lines you should erase with your eraser are shown using dotted lines.

Ballpoint Pens and Felt-Tipped Markers

Try drawing the entire picture at once. You won't be able to erase your mistakes, but you can draw things pretty quickly.

Colored Pencils and Colored Felt-Tipped Markers

Coloring can also be a lot of fun. You don't have to color the entire picture. Leave some white space. Wrapping up your drawing with just a few colors can add a really nice finish.

Notebooks, Appointment Books, Memo Pads, Etc.

You can use whatever you can find around you for your canvas. I recommend doodling, as long as your doodles don't interfere with your studies or your work.

the basics of the basics

Learning some basic skills helps make drawing easy. But, remember, the basics are nothing more than a fundamental starting point.

1. Draw larger shapes first

Draw the head before you draw the eyes or the nose, draw the body before you draw the hands, feet, or other patterns. Try to get an idea of the overall shape before you add the fine details.

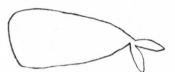

2. Draw from top to bottom, right to left

Pick up your pen or pencil and try waving it around. Can you feel how natural it is to move it from top to bottom or right to left? (Or left to right, if you are left-handed!)

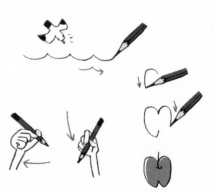

3. Draw the head before you draw the body

When you draw the head, you can get a feel for your animal's personality and what it is probably thinking at the time. This makes it easier for you to decide how to draw the rest of the body

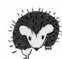

This hedgehog looks so friendly he could be walking down any street.

The Basics Can Be contradictory

Sometimes the basics described in steps 1, 2 and 3 will seem to contradict each other, and you may have a hard time deciding where to start. If that is the case, just start wherever you want.

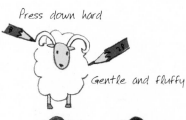

After drawing the wiggly shape, draw the face

After drawing the face, add color to the body

4. Apply different pressures to the tip of your pen

Press hard when you draw the solid parts and lightly when you draw the soft parts. You can draw a lot of different lines with the same pen just by applying different amounts of pressure.

Press down hard

Gentle and fluffy

Leave uncolored

Gently shade with gray

Color in strong black

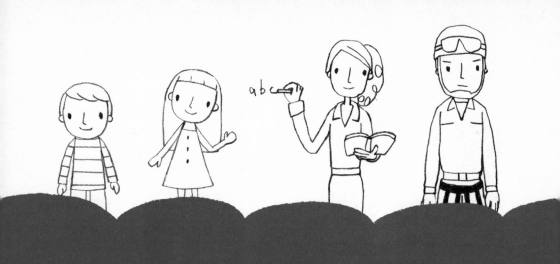

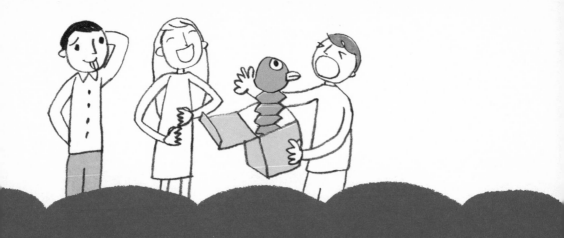

happy people

a boy's song

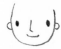

A round, round moon has
come out, you know.
(Draw the outline of a boy.)

Two black beans have
fallen into place.
(Draw the eyes.)

With a sweet smile,
"good afternoon"
(Draw the nose,
mouth, and ears.)

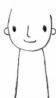

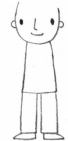

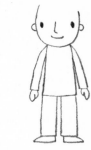

Well, well, well,
you've grown so tall.
(Draw the trunk.)

You've gone and
grown taller again!
(Draw the legs and feet.)

Stretch both arms down
as far as they will go.
(Draw the arms and hands.)

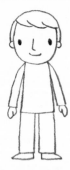

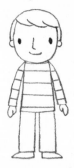

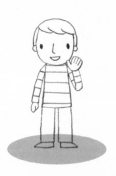

He didn't want to,
but he went for a haircut
(Draw the hair.)

Draw the stripes and there
you have the boy!
(Draw the pattern on the
T-shirt and it is finished.)

let's draw!

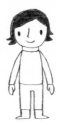 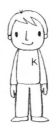

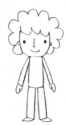

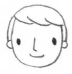 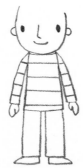

I can't find my clothes I hate going to the hairdresser! Hi!

a girl's song

There's a round, round plate
(Draw the outline of a girl.)

Watermelon seeds
have fallen into place.
(Draw the eyes.)

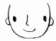

With a sweet smile she's
in such a good mood.
(Draw the mouth and nose.)

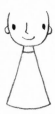

A triangular dress
makes her look so chic.
(Draw the trunk.)

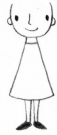

She really likes the
little shoes, as well.
(Draw the legs.)

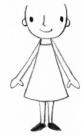

She always has
the proper posture.
(Draw the arms and hands.)

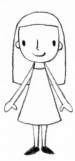

She also likes long hair.
(Draw the hair.)

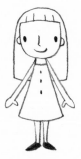

Add the buttons, and
there you have the girl!
(Draw the buttons and the
hair bangs, and it's finished.)

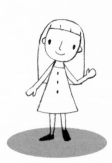

let's draw!

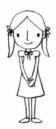 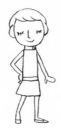 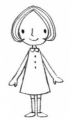

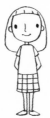

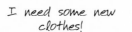

I need some new clothes!

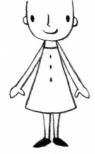

I want to change my hairstyle.

Nice to meet you!

drawing various expressions

Let's try to convey various emotions by drawing different expressions.
You can create a number of different expressions by varying the shape of the
eyes and mouth and the direction the face is looking.

faces seen from the front

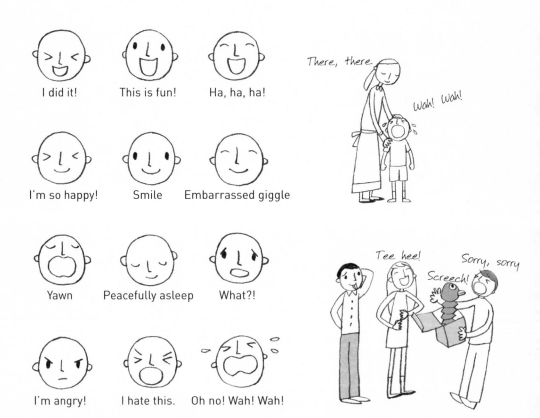

I did it!

This is fun!

Ha, ha, ha!

I'm so happy!

Smile

Embarrassed giggle

Yawn

Peacefully asleep

What?!

I'm angry!

I hate this.

Oh no! Wah! Wah!

There, there.

Wah! Wah!

Tee hee!

Sorry, sorry

Screech!

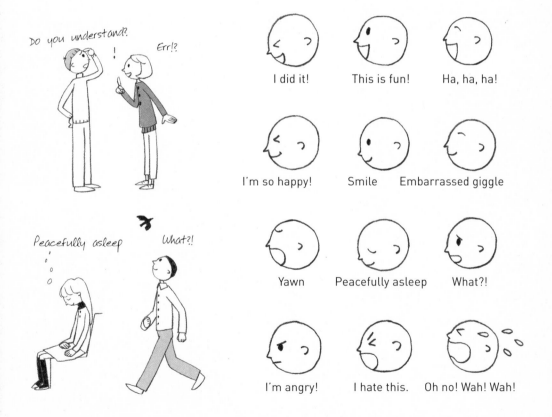

Do you understand? ! Err!?

I did it! This is fun! Ha, ha, ha!

I'm so happy! Smile Embarrassed giggle

Peacefully asleep What?!

Yawn Peacefully asleep What?!

I'm angry! I hate this. Oh no! Wah! Wah!

a lively mother

*Clothes that are easy to move in
suit mothers who are always lively.*

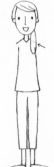

It is easier to decide
where to start drawing
the arms if you draw the
shoulders and sides at
the same time.

1. Draw a cheerful expression
and a tied-back hairstyle.

2. Draw the body and the
pants and then the legs.

3. After drawing the collar,
place the hands on the hips
and, finally, draw the rolled-up
sleeves on the arms.

a kind mother

Relaxing designs suit mothers who are always kind.

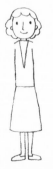

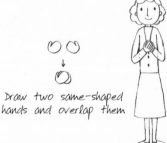

Draw two same-shaped
hands and overlap them

1. Draw a benign-looking face
and lightly permed hair.

2. Draw the body and the skirt
and then the legs.

3. Draw the buttons and
gently clasp the hands.

let's draw!

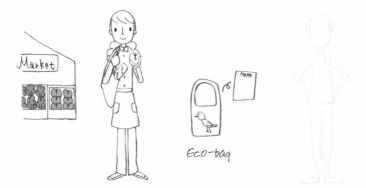

Eco-bag

A mother busy shopping

A lively mother

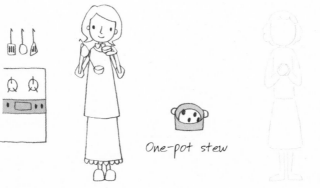

One-pot stew

Mother's belongings

A kind mother

a stylish father

The chic glasses worn by this stylish father really suit him.

Decide where the parting for
the fringe should be.

↓

Shift the glasses a little
to show the eyes

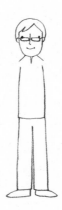

Both arms are crossed
in this way.

The left arm
in front.

The right arm
in front.

The left hand
in front.

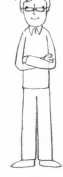

1. Draw a gentle expression,
a hairstyle, and stylish glasses.

2. Draw a slim body and
then the pants and shoes.

3. Draw the collar
and folded arms.

a plump father

A large-bodied father looks strong and solid,
as if he could protect you from anything.

There is extra flesh
around the bottom and
stomach giving him a
bottom-heavy shape.

1. Draw a chubby face
and the hair.

2. Dress his large body in a
cardigan and draw his
pants and shoes.

3. After drawing his arms,
let's button-up his cardigan.

let's draw!

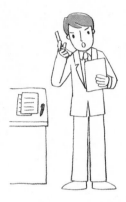

Father working

What father carries

Documents

A stylish father

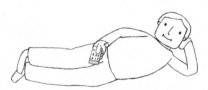

Sunday father

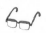
Glasses

Newspaper

A plump father

crawling baby

Babies use their whole bodies to gradually move forward.

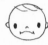

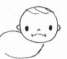

The knees and palms of the hands are touching the floor.

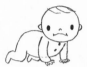

1. Draw a round face and plump cheeks.

2. Draw a plump stomach and rounded back.

3. Draw plump hands and feet and add buttons.

toddling baby

The baby stands up firmly on little legs.

⌒ Draw the upper lip.
◡ Draw the lower lip.
▷◁ The point to accentuate is the plump cheeks.

Slightly bow-legged

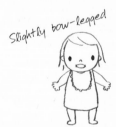

1. Draw the round face and the hair that has grown a little.

2. Draw the dress and legs.

3. Draw the arms that help to keep the balance.

let's draw!

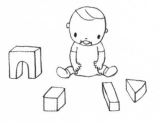

Baby's possession

Crawling baby

A cradle

Mobile

Duck toy

Toddling baby

consider the poses from the bones

When drawing the whole body, try to think roughly about the balance of all of the bones and the location of the joints. If you plan the pose starting from the bones you may be surprised to find that you can draw even difficult poses.

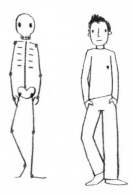

When you are leaning to the left, the bones look something like this.

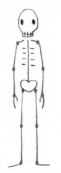

When you are standing, the bones look something like this.

When you are drinking tea, the bones look something like this.

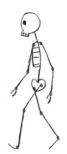 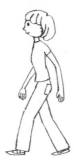

When you are walking,
the bones look something like this.

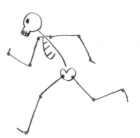 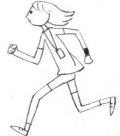

When you are running,
the bones look something like this.

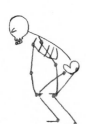 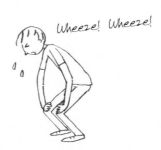

Wheeze! Wheeze!

When taking a rest,
the bones look something like this.

businesswoman

Regardless of how hard the work is, she carries it out energetically and with a smile.

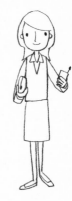

1. Draw her face and hairstyle.

2. Draw her body in a suit, her skirt, and her legs.

3. Put a clutch-bag in one hand and a mobile phone in the other.

businessman

In the heat or in the cold, every day he puts on a suit and diligently completes his work.

Give him a snappy hairstyle.

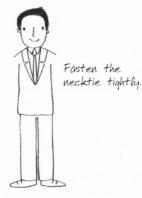

Fasten the necktie tightly.

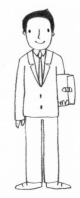

1. Draw his face and hairstyle.

2. Draw him wearing a suit and trousers.

3. Give him some documents to carry under his arm.

let's draw!

What the career woman carries

Her packed lunch

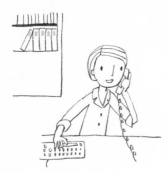

Her schedule book

Let's draw a career woman.

What the businessman carries

A personal computer

Let's draw a businessman.

police officer

He patrols the streets every day to protect the safety of our town.

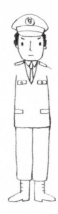
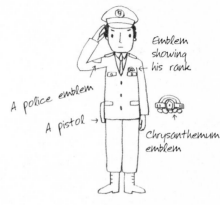

A police emblem

A pistol →

Emblem showing his rank

Chrysanthemum emblem

1. Draw his face, hat, and hair.

2. Draw his body in a uniform, his pants, and his shoes.

3. Draw his hands, add the pistol, and badges.

fireman

In preparation for fire-fighting he undertakes strict training.

Emblem on his helmet

Snow crystal

Leaves

The area around his neck is protected as well

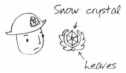

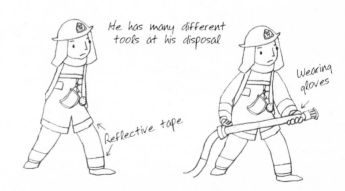

He has many different tools at his disposal

Reflective tape

Wearing gloves

1. Draw the face and helmet.

2. Draw the upper part of the fireman's uniform, the pants, shoes, and equipment.

3. Put a hose in his hands.

let's draw!

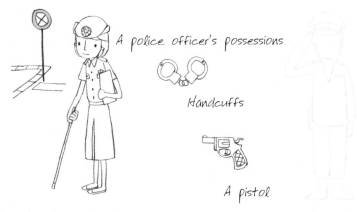

A police officer's possessions

Handcuffs

A pistol

A female police officer

Let's draw a police officer.

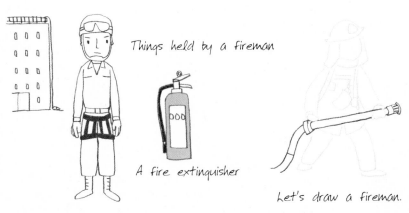

Things held by a fireman

A fire extinguisher

A rescue worker

Let's draw a fireman.

teacher

She wears a proper uniform to be a good example to her students.

Part the hair at the side.

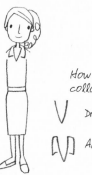

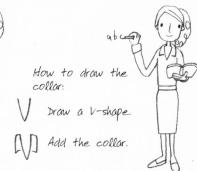

How to draw the collar:

V — Draw a V-shape.

W — Add the collar.

1. Draw the face and the neatly arranged hair.

2. Draw a shirt with a collar, her skirt, legs, and shoes.

3. Give her some chalk and a textbook.

artist

He is wearing clothes that can be stained. For him the most important thing is for his picture to be beautiful.

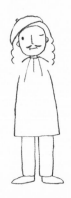

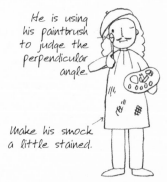

He is using his paintbrush to judge the perpendicular angle.

Make his smock a little stained.

1. Draw his face, beret, and bushy hair.

2. Draw his smock, pants, and shoes.

3. Draw some stains on his smock and give him a brush and palette.

let's draw!

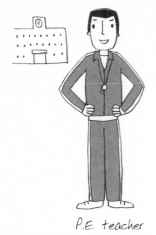

P.E. teacher

A teacher's possessions

A register

Chalk and
blackboard eraser

Let's draw a teacher.

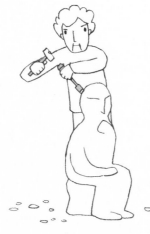

A sculptor

An artist's tools

Paints

Painting knife

Let's draw an artist.

astronaut

The astronaut's suit is equipped with many kinds of life-support instruments.

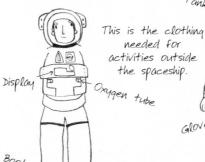

Tank

This is the clothing needed for activities outside the spaceship.

Display

Oxygen tube

← Light

Boots →

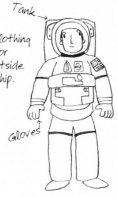

Gloves

1. Draw the face and helmet.

2. Draw the body, pants, boots, and space instruments.

3. Draw the gloved hands and the tank.

explorer

He is equipped with every possible instrument to deal with danger.

Draw the visor of the hat.

Draw the hat just the right size for the head to fit into.

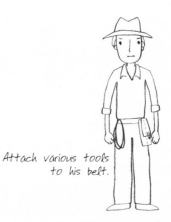

Attach various tools to his belt.

1. Draw the face, hat, and hair.

2. Draw the body, pants, and shoes.

3. Draw the hands, rope, and money pouch.

let's draw!

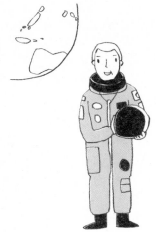

Astronauts' transport
Space shuttle

Draw an astronaut.

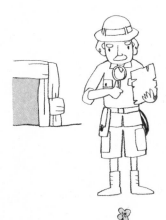

Explorer's possessions

Binoculars

Survival knife

Draw an explorer.

the frame of mind of a stylist

Try to imagine the feelings that the person you are drawing may have and think about what kind of clothing that person would like. By looking in shops and magazines and observing people on the streets, you can get gather some ideas about the various kinds of clothes there are, and it can lead to a lot of fun trying to draw them.

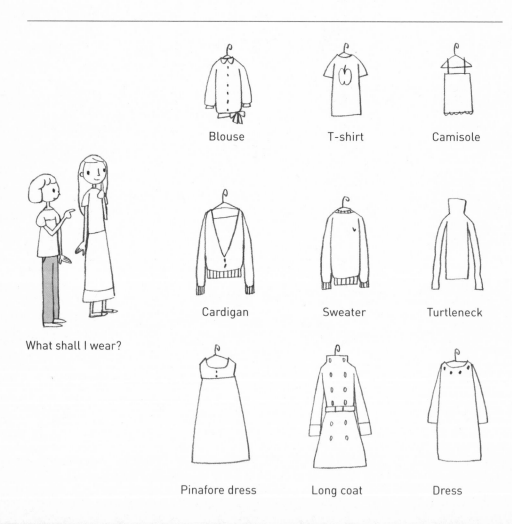

What shall I wear?

Blouse

T-shirt

Camisole

Cardigan

Sweater

Turtleneck

Pinafore dress

Long coat

Dress

Mini-skirt

Long skirt

Capri pants

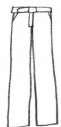
Jeans

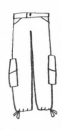
Cargo pants

Down jacket

Bikini

Boots

Pumps

Sneakers

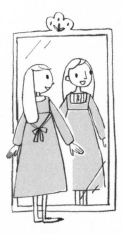

the little mermaid

After falling in love with a prince, she makes up her mind to exchange her voice for life as a human.

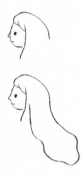

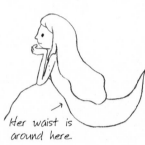

Her waist is around here.

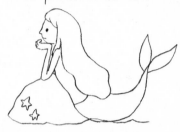

Draw the rock and determine the position of her elbow.

1. Decide the shape of her head and draw her face and long hair.

2. Draw her arm, with the elbow, and a smooth body—like a fish.

3. Draw her waist and tail.

pinocchio

He hates both studying and making an effort. He can be easily tricked using flattery.

Draw the outline of his face.

Add his hat and hair.

His nose is his special feature.

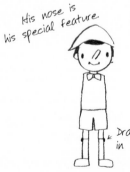

Draw the screws in his joints.

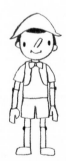

1. Draw his face with a long nose, hat, and hair.

2. Draw his wooden body and legs.

3. Draw his hands and jacket.

let's draw!

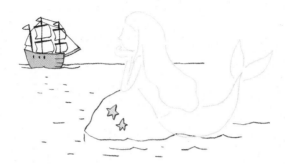

Let's draw The Little Mermaid.

Wow!

Let's draw the nose that grows longer and longer.

The talkative cricket.

Let's draw Pinocchio.

witch

Although most of the witches that appear in stories are bad, there must be good witches as well.

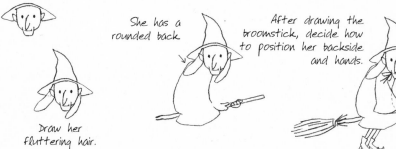

She has a rounded back

After drawing the broomstick, decide how to position her backside and hands.

Draw her fluttering hair.

1. Draw her face with a pointed nose, a her triangular hat, and her hair.

2. Draw the broomstick and her hands grasping it.

3. Draw her legs hanging down and the end of the broom.

wizard

The wizard does not only use magic, but also he uses his deep insight to fulfill his role as a guide in people's lives.

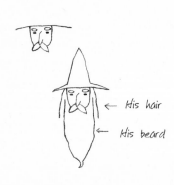

← His hair

← His beard

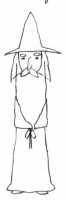

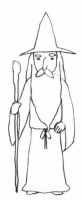

1. Draw his face with a splendid beard, his long hair, and his triangular hat.

2. Draw his clothes tied with a drawstring and his shoes.

3. Draw big sleeves and a magic wand in his hands.

let's draw!

Good witch

Black cat

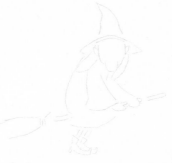

Let's draw a witch.

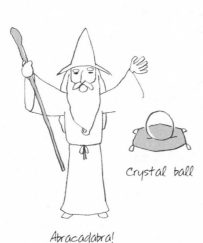

Crystal ball

Abracadabra!

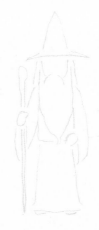

Let's draw a wizard.

tips for drawing portraits

When you look at someone or recall them, what do you feel is the main feature that stands out? If you focus on that one feature, it is strange the way the whole picture comes to resemble the person. Have a look at the pictures below as a reference.

face illustration guide

Various face shapes

Round Long Chubby

Triangular Square Pentagonal

Various eyes

Wide-open Looking down Looking up

Heavy eyebrows Calm Small eyes

Various noses

Key-shaped nose Long nose Dumpling nose

Various mouths

Pursed lips Thick lips Tee, hee, hee

Pig nose Small nose Turned-up nose

Chubby cheeks Older Nihilistic

what kind of people are around you?

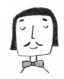

Coffee shop owner

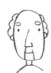

The old man next door

Cool older friend

The exchange student

The girl working
in the Indian restaurant

The woman working
in the barbershop

One of the local kids

A receptionist

Piano teacher

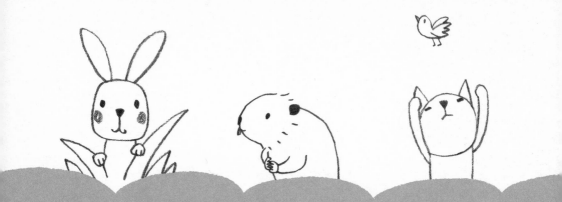

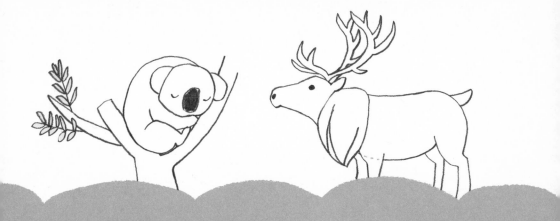

SECTION TWO

animals

 ♪1

Raisins, I found three
(Draw the shape of the face and some black round dots for the eyes and nose.)

 ♪2

I carve a few lines in my bread
(Draw lines that extend to and connect the mouth and nose.)

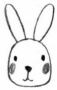 **♪3**

Fresh rolls baked golden brown
(Draw the ears tilting sideways from the center of the top of the head.)

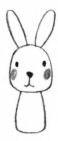 **♪4**

One loaf of sandwich bread hot out of the oven
(Draw a long, slim body.)

 ♪5

Stomp the ground with my feet
(Draw legs with large feet.)

 ♪6

Double your fingers and clench your fists
(Draw the arms extending from both sides of the body.)

 ♪7

I see your tail, you're Rabi the Rabbit
(Once you've drawn the tail, you are done!)

let's draw!

Jump! Zzzzz Munch Hmnnn long, hard stare Thump, thump, thump

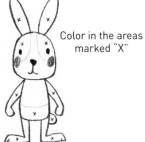

Color in the areas marked "X"

Pandarabi, I found you! Droopy Ear Rabbit, I found you! Rabi Rabbit, there you are!

kumapon, the bear song

♪1
**A big dumpling,
just a little pull**
(Draw the shape of the face
and the protruding nose.)

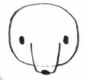

♪2
**Add three beans
and clean up a little**
(Draw black dots for the
eyes, the tip of the nose,
and erase the extra line.)

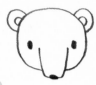

♪3
**Stick on doughnuts, a
half on each side**
(Draw two double half
circles for the ears.)

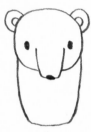

♪4
Add a plump rice cake
(Draw a squat body.)

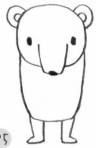

♪5
I found a pair of boots
(Draw the stubby
toes and the legs.)

♪6
Stretch out the rice cakes
(Draw the arms extending
from both sides of the body.)

♪7
**I see your tail, Kumapon Bear!
He's coming out of the woods!**
(Once you've drawn the
tail, you are done!)

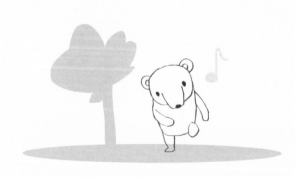

let's draw!

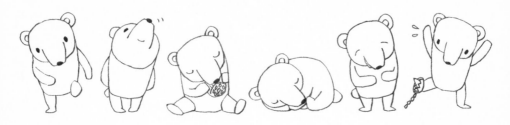

| Step, step | Sniff, sniff | Munch, munch | Zzzzz | Ha, ha, ha | Eeyow! |

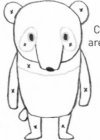

Color in the areas marked "X"

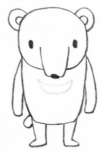

Pandapon Bear's here, too!

And Crescent Moon Bear, too!

nyanta, the cat song

♪1

I poked some holes
in a bean-jam bun
(Draw the face, the eyes,
and the lines of the nose.)

♪2

Bean-jam oozes
outside from the inside
(Draw the nose and
mouth.)

♪3

Start with a bite of the
tasty crust
(Draw the triangular
ears.)

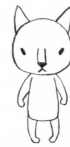

♪4

Plump and round, my
tummy's full
(Draw a round, soft
body.)

♪5

Creeping along
on tippy-toes
(Draw the rounded legs
and small paws.)

♪6

Clench the pads on both
hands into fists
(Draw the arms
extending from both
sides of the body.)

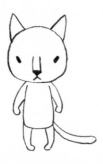

♪7

Look, there's Nyanta saying
"hi" with a wave of his tail!
(Once you've added the tail,
you are done!)

let's draw!

Stretch

Phew!

Flip-flop

Jump!

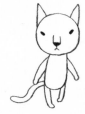

Quick step

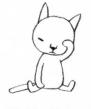

Washing his face

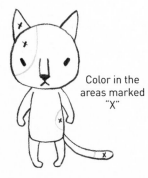

Color in the areas marked "X"

Look, there's Mikenekomi, the Calico cat!

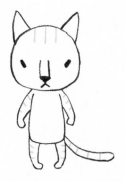

And there's Jiro, the striped cat!

And Nyanta, too!

drawing diverse facial expressions

Thinking about what your character may be feeling as you draw a variety of facial expressions can help you create fun illustrations. Let's try it!

diverse animal expressions

Front views

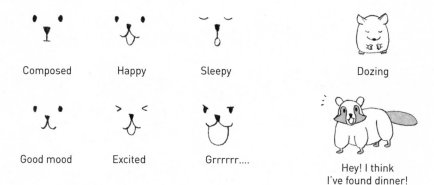

Composed Happy Sleepy Dozing

Good mood Excited Grrrrrr....

Hey! I think
I've found dinner!

Side views

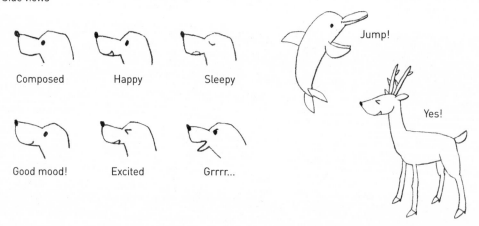

Composed Happy Sleepy Jump!

Good mood! Excited Grrrr... Yes!

diverse animal expressions (bills)

Front views

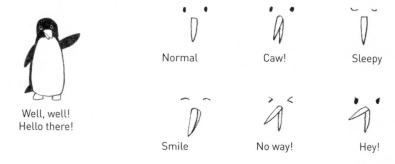

Well, well!
Hello there!

Normal

Caw!

Sleepy

Smile

No way!

Hey!

Side views

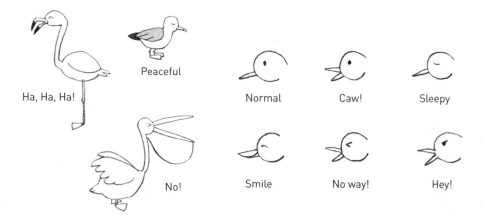

Ha, Ha, Ha!

Peaceful

No!

Normal

Caw!

Sleepy

Smile

No way!

Hey!

horses

These gentle and friendly animals have sensitive personalities and value their relationships of trust with human beings.

Horses are square-jawed.

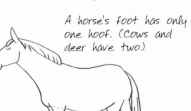

A horse's foot has only one hoof. (Cows and deer have two.)

They have boney, thick stomachs, backs, and bottoms.

1. Draw the head, ears, neck, eyes, nose, and mane.

2. Draw a burly body.

3. Draw strong legs and hoofs and a fluffy tail.

donkeys

Donkeys have great memories and are very strong. their ears are adorable and big.

The color pattern changes here.

Big ears and big eyes are their trademark

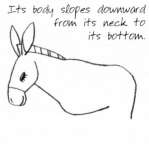

Its body slopes downward from its neck to its bottom.

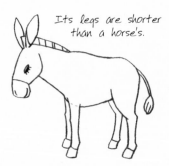

Its legs are shorter than a horse's.

1. Draw a large head, eyes, nose, and mouth.

2. Draw the back, bottom, chest, and mane.

3. Draw slightly short legs and a tail.

let's draw!

The horse's back does not curve when it gallops, making it perfect for riding!

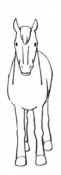

Let's draw a horse.

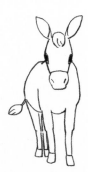

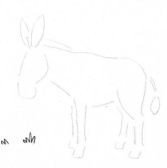

Let's draw a donkey.

Donkeys can remember the way back and forth over a span of a few kilometers.

deer

Only the male deer has antlers. They are shed and grow back every year and become more stately with age.

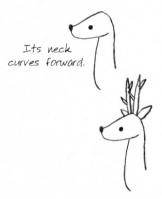

Its neck curves forward.

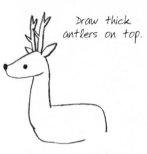

Draw thick antlers on top.

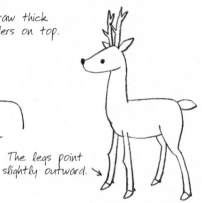

The legs point slightly outward.

1. Draw the head and a long, shapely neck, eyes, nose, and ears. On top of it all, draw antlers.

2. Draw the back, bottom, and chest.

3. Draw long-hoofed legs and a short tail.

reindeer

Both males and females have antlers, which are shed every year in the winter by the male, and in the spring by the female.

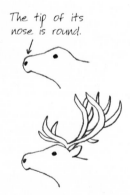

The tip of its nose is round.

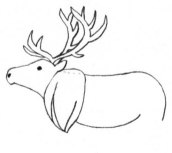

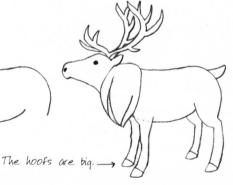

The hoofs are big. →

1. Draw the head, eyes, nose, ears, and the expansive antlers.

2. Draw a luxuriant muffler-like mane and the back, buttocks, and stomach.

3. Draw its thick legs, hooves, and the short tail.

let's draw!

When it is surprised, its tail hair turns upward.

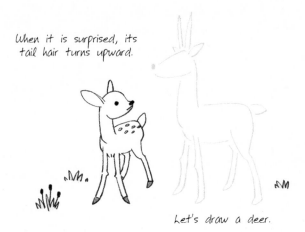

Let's draw a deer.

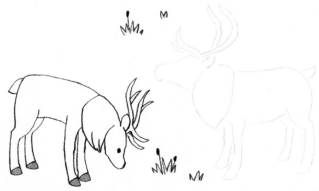

Reindeer are the only animals whose female counterparts grow antlers.

Let's draw a reindeer.

kangaroos

Kangaroos raise their young in their stomach pouches. Newborn cubs will find their own ways into their mother's pouch.

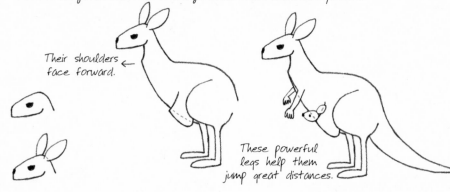

Their shoulders face forward.

These powerful legs help them jump great distances.

1. First, draw the nose, head, triangular eyes and ears.

2. Draw a big body and powerful hind legs and a stomach with a pocket.

3. Finish by drawing the forelegs and tail, and a baby kangaroo in its pouch!

koalas

Since its main diet of eucalyptus leaves does not provide much nourishment, to conserve energy it spends most of its time sleeping.

Large round ears and nose are their most distinctive features.

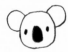

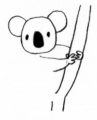

They hold on tightly with their tiny hands.

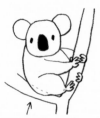

They have no tails.

1. Draw a round head and ears, a large nose, and eyes.

2. Draw forelegs holding tightly to a branch and the branch itself.

3. Draw the hind legs tightly gripping the branch, its buttocks, and the branch it is perched on.

let's draw!

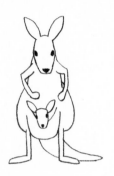

Want to box?

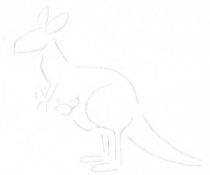

Let's draw a kangaroo.

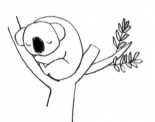

He spends most of
his life in a tree.

Let's draw a koala.

to render a pose, start with the skeleton

With their long necks and noses, wings or tails, animals' poses can be quite unique and interesting. Getting a general idea of their skeletal structures and the positions of their joints can give you hints as to the poses they assume.

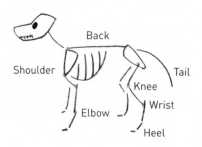

Back

Shoulder

Tail

Knee

Wrist

Elbow

Heel

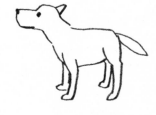

Do you think this is how a dog's bones look?

Their long noses are made solely of cartilage and contain no bones at all.

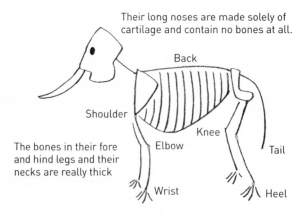

Back

Shoulder

Knee

The bones in their fore and hind legs and their necks are really thick

Elbow

Tail

Wrist

Heel

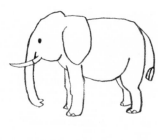

Do you think this is how an elephant's bones look?

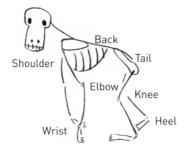

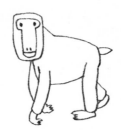

Do you think this is how a monkey's bones look?

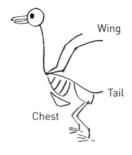

Do you think this is how a bird's bones look?

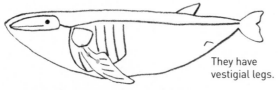

They have vestigial legs.

Their chest fins have bones that extend from their shoulders to their fingers

Do you think this is how a whale's bones look?

tigers

*A tiger will lay in wait,
carefully stalking its prey, but its success rate is rather low.*

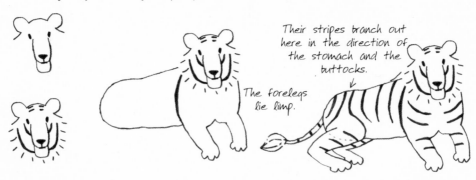

Their stripes branch out here in the direction of the stomach and the buttocks.

The forelegs lie limp.

1. Draw the head, nose and chin, the eyes and tiger pattern, and a luxuriant profile.

2. Draw the forelegs large and extending forward, and a huge body.

3. Draw the thick legs and the tail and add the tiger stripes.

cheetahs

*recording top speeds of 68 mph (110 kmh),
these are the fastest animals on Earth.*

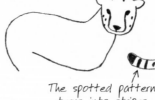

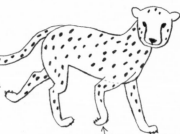

The bags under its eyes are its trademark (a trait that sets it apart from the leopard).

The spotted pattern turns into stripes toward the tip of the tail

Its nails are always exposed.

1. Draw the head, eyes and ears, the bags under the eyes and the nose, and the spots.

2. Draw a slim body and buttocks.

3. Draw the paws that kick lightly at the ground and the tail.

let's draw!

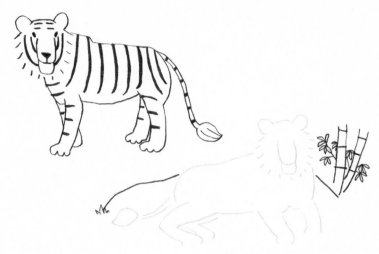

Let's draw a tiger.

Let's draw a cheetah.

Cheetah cubs have
fluffy, furry faces.

giraffes

The giraffe is the tallest animal in the world. Its blood pressure is extremely high so as to facilitate sending blood to its head.

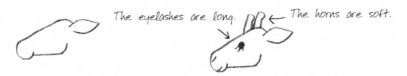

The eyelashes are long. → The horns are soft.

1. Draw the head, nose and ears, the eyelashes, and horns.

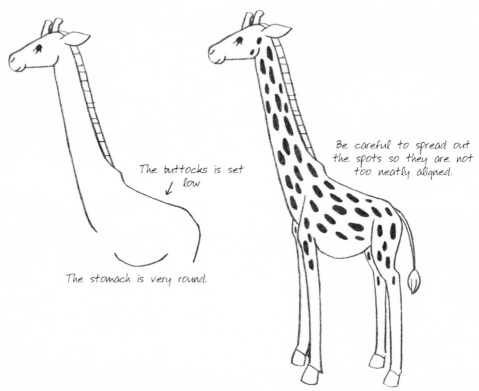

The buttocks is set ↓ low

The stomach is very round.

Be careful to spread out the spots so they are not too neatly aligned.

2. Draw the long neck and mane and the body that supports them.

3. Draw the long, slim legs and hoofs, the tail, and spots.

let's draw!

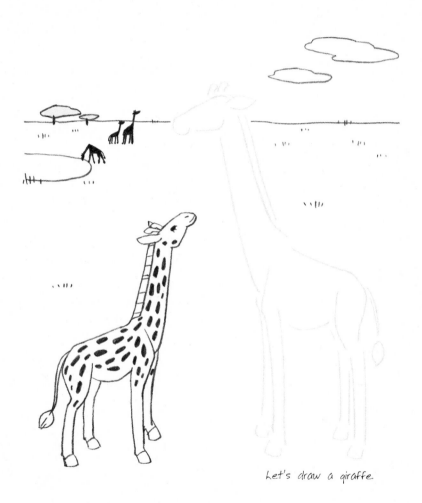

Let's draw a giraffe.

African elephants

The elephant is the largest animal in the world.
Its dexterous nose can act as both a shower and a snorkel.

Tusks grow
from the base
of its nose.

The upper and lower
protrusions at the tip
of its nose allows it
to grip things.

1. Draw the head, the long nose,
the eyes, large ears, and tusks.

2. Draw the large back,
buttocks and stomach.

3. Draw the large, sturdy
legs and nails and the tail.

Their forepaws have four nails
and the hind paws have three.

let's draw!

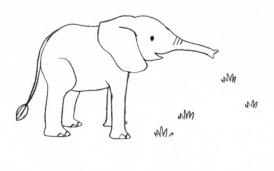

The African elephant has large ears.

Asian elephants have jutting foreheads and small ears.

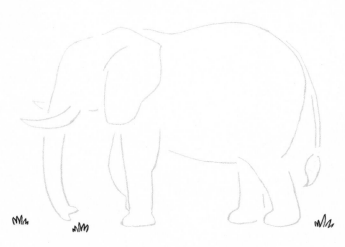

Let's draw an African elephant.

which animal made these footprints?

Horses, rhinoceroses, and so on leave odd-number hoof prints, while the hoof prints of cows, pigs, and the like are even-numbered. There are also animal prints like that of the monkey, which has fingers, and the duck, which has webbed feet.

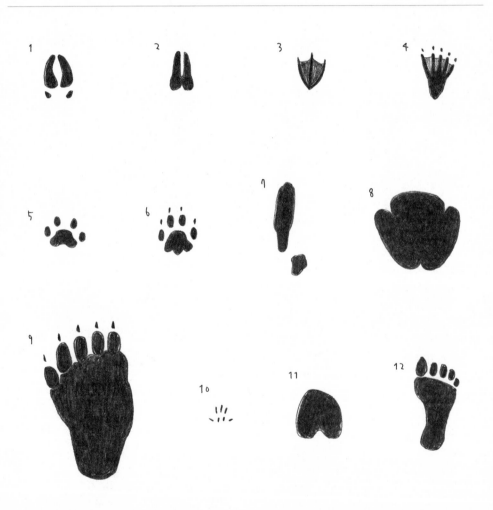

Quiz: Choose the animal that made the footprints on the previous page.

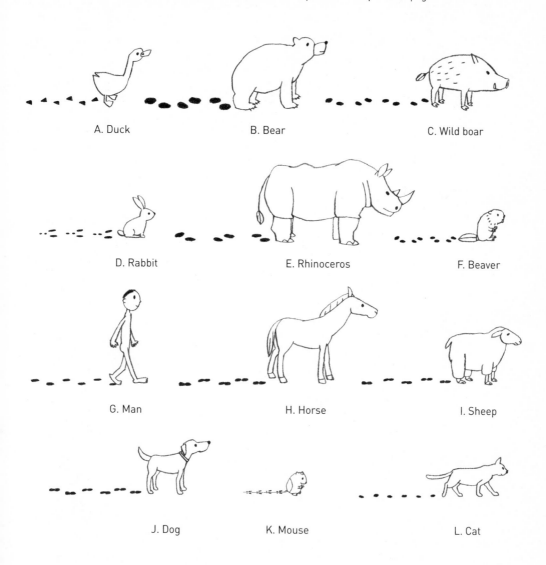

A. Duck

B. Bear

C. Wild boar

D. Rabbit

E. Rhinoceros

F. Beaver

G. Man

H. Horse

I. Sheep

J. Dog

K. Mouse

L. Cat

Answers: A(3) B(9) C(1) D(7) E (8) F(4) G(12) H(11) I(2) J(6) K(10) L(5)

emperor penguins

At heights of up to 51 inches (130 cm), these penguins are the biggest of their kind. They have a yellow pattern on their necks.

It has a pattern on its neck

The tips of their bills are curved downward.

1. Draw the head and eyes, and a bill that curves downward at its tip.

2. Draw the large, squat body and the body pattern.

3. Draw the wings, feet, and tail feathers, and then color in the black portion of the body pattern.

Adelie penguins

These small penguins grow to heights of about 23 inches (58 cm). They have long tail feathers and pink feet.

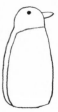

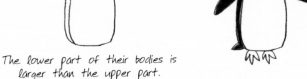

The lower part of their bodies is larger than the upper part.

1. Draw the head, the eyes, and the bill.

2. Draw a small, squat body and the body pattern.

3. Draw the wings, feet and tail feathers, and then color in the black portion of the body pattern.

let's draw!

A rockhopper penguin

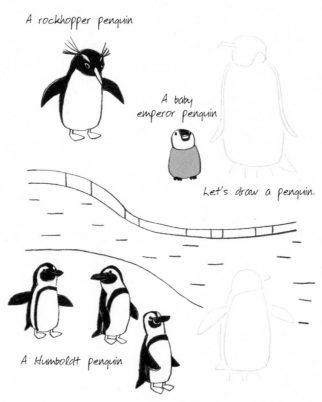

A baby
emperor penguin

Let's draw a penguin.

A Humboldt penguin

Let's draw an Adelie penguin.

beavers

Beavers build huge dams in the vicinity of their nests, using tree branches and mud. They enter their nests from underwater entrances.

Their ears are black

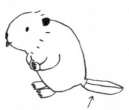

They have buck teeth.

They have slightly slouching postures.

Their tails are flat and act as a rudder.

1. Draw the head and nose, the eyes and ears, and their buck teeth.

2. Compared with the body, the head is quite large.

3. Draw the forepaws, hind legs, and the tail.

otters

Otters create a blanket out of seaweed by wrapping it around their bodies when they sleep. Their babies sleep on their mothers' stomachs.

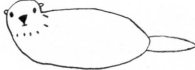
A shell looks like this.

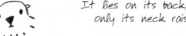
It lies on its back, with only its neck raised.

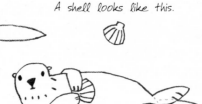

1. Draw the head and nose, the eyes and ears, and the mouth.

2. Draw a lazy body and tail.

3. Draw the hands and feet and a shell.

let's draw!

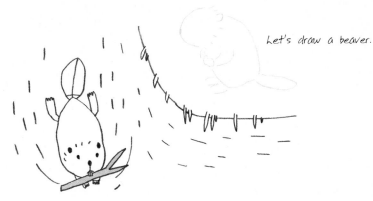

Let's draw a beaver.

Its nostrils close off underwater.

Beavers are river-dwellers,
and otters live in the ocean.

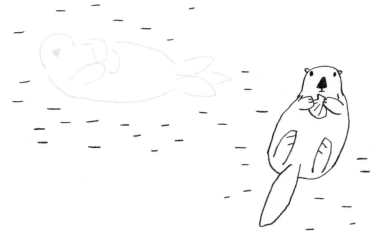

Let's draw an otter.

miniature dachshunds

It is said that their legs grow short to give them easier access to badger nests.

The nose and the forehead

The ears and jaws

Draw the body twice as long as you think it is.

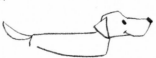

Draw the legs half as long as you think they are.

1. Draw the head, nose and eyes, and the ears and jaws.

2. Draw the lengthy body and the tail.

3. Drawn the cute, short legs.

toy poodles

these extremely smart dogs enjoy learning new things.

The nose and forehead

The ears and neck

Draw a solid mass of fur keeping in mind the shape of the body.

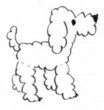

1. Draw the head, nose eyes, ears, and neck.

2. Draw a body with a thick mass of fur.

3. Draw the legs and dainty claws.

let's draw!

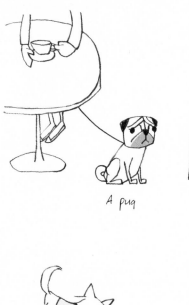

A pug

A yorkshire terrier

A chihuahua

A Boston terrier

Let's draw a miniature dachshund.

Let's draw a toy poodle.

golden retrievers

These gentle dogs have powerful bodies and a strong sense of family.

The forehead and jaws

Draw luxuri-
ant fur on the
chest and, oddly
enough, the
entire body
seems luxurious.

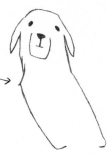

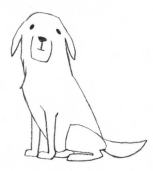

1. Draw the large head, droopy ears, and thick neck.

2. Draw the hefty chest and back.

3. Draw the stout legs and thick tail.

dalmatians

*Long ago, dalmatians used to run alongside horses,
protecting horse-drawn carriages from thieves.*

The base of
the ears rests
slightly below
the head.

The body becomes slimmer
the closer it comes to
the buttocks.

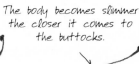

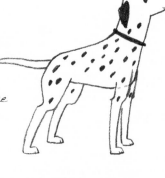

The shape of the legs would look like
this if compared to a man's legs.

The knee

The heel

1. Draw the large head, pointed nose, the droopy ears, and the neck.

3. Draw the long legs, a svelte tail, and the spots.

2. Draw the sleek, muscular body, and a collar.

let's draw!

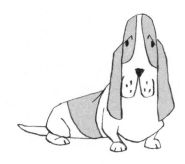

A basset hound

Let's draw a golden retriever.

Let's draw a dalmatian.

A Japanese dog

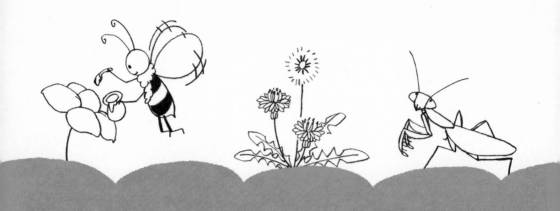

SECTION THREE

plants & creatures

the little bee song

 ♪1 If you take a peek inside a round, round hole

 ♪2 You can see my face reflected inside

 ♪3 Add two antennae and a puffy-cloud scarf

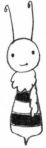 **♪4** And now I'm on top of a stripy, spinning top

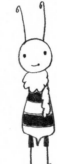 **♪5** Look out, look out, there's danger down there

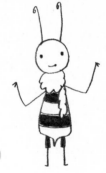 **♪6** Oh, I need two arms to balance, don't forget

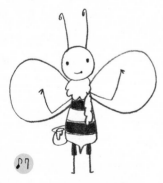 **♪7** And finally two wings so Little Bee can fly!

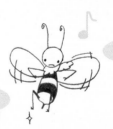

let's draw!

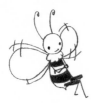

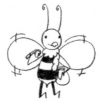

Trying out my wings

Working perfectly

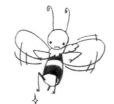

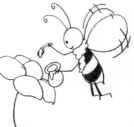

Fly, fly, fill it up

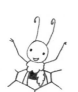

At last I'm home!

I'm going to sting you!

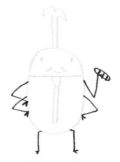

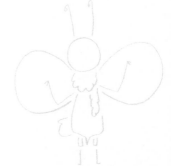

Mr. Rhinoceros Beetle is the boss!

Mr. Stag Beetle loves to play around!

Little Bee is a hard worker!

the little miss sunflower song

 ♪1 Guess what, I've found a secret hole

 ♪2 If you quietly take a look inside

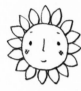 ♪3 Fireworks burst out with a bang

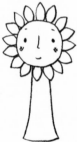 ♪4 Feeling so happy I blow on a trumpet

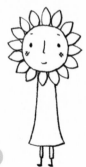 ♪5 Tra-la-la, music notes jump up and down

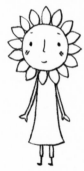 ♪6 Ribbons are swaying in the wind

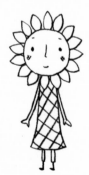 ♪7 And Little Miss Sunflower looks so chic in her dress

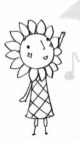

let's draw!

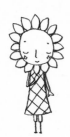 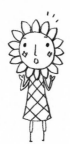 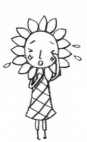 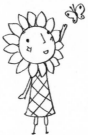 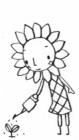 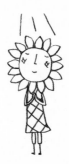

Nice to meet you.

Oh dear!

Sob, sob

I'm in a good mood.

Please grow for me.

I love the sun.

Miss Dandelion is rather shy!

Little Pansy is a little precocious!

Little Miss Sunflower is cool and chic!

making characters

Let's try making flowers, fruits, trees, and insects into characters by drawing their faces, arms, and legs. By adding poses and expressions you can fill the characters with plenty of humor and transform them in many ways.

flower characters

I was wondering what kind of clothes they should wear...

In this case, I decided to try and draw clothes in the shape of petals.

fruit characters

I imagined the personalities of each character and designed clothes that I thought would suit them.

various expressions

Smile! Ha, ha, ha Blushing Humph Wah!

tree characters

This grandfather tree is getting on in years.

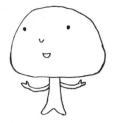

The branches and under-growth look like hands.

I'm living in harmony with other small creatures.

insect characters

Try making big eyes into glasses.

It's fine to leave out the "arms" in the middle, just as you please.

The small prickles are short and cute and look like hands.

The patterns on the wings can create a sense of beauty.

cherry blossoms

The salt-pickled leaves that are used for cherry blossom rice cakes are from the oshima cherry trees.

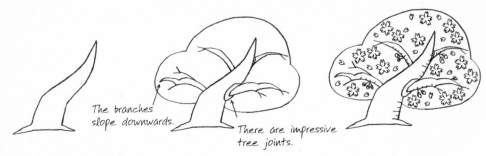

The branches slope downwards.

There are impressive tree joints.

1. Draw a trunk that has a strong undulating curve to it.

2. Draw curved arc–shaped branches and the whole outline of the blossoms on the tree.

3. Add the blossoms, buds, and sideways lines on the trunk.

rape blossoms

The leaves can be boiled and eaten, the seeds are used to make oil, and the strained lees to make fertilizer.

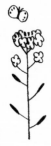

1. After drawing the flowers in the foreground, draw the flowers behind them, as well.

2. Draw a long, straight stem stretching upwards.

3. Finish it off by adding the flowers, seeds, and leaves arranged alternately from the top down.

let's draw!

Draw lots and lots of
cherry blossoms and petals.

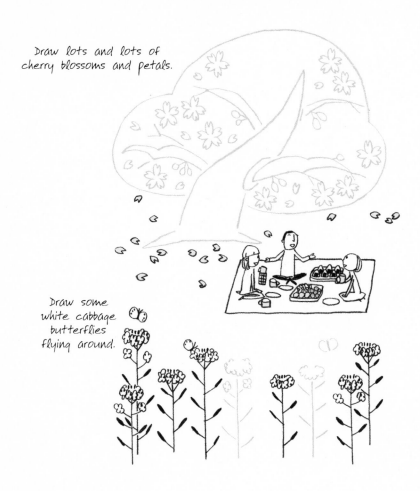

Draw some
white cabbage
butterflies
flying around.

tulips

They were introduced to the Netherlands from Turkey and became so popular that they made a great economic impact.

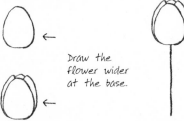

Draw the flower wider at the base.

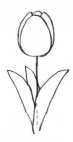

1. Expand the flower by drawing the front, side, and back petals in that order.

2. Draw a long, straight stem stretching upwards.

3. Overlap the pointed leaves from the base of the flower.

daisies

Because daisies bloom for a long time they have several other names in Japanese that mean "long-lived."

Draw petals in between petals.

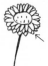

Increase the thickness of the flower by drawing another layer of petals on the underside.

1. Decide on the center and then draw layers of overlapping petals.

2. Draw a stem that is not very long.

3. Finish the picture by drawing jagged-edged leaves overlapping on the ground.

let's draw!

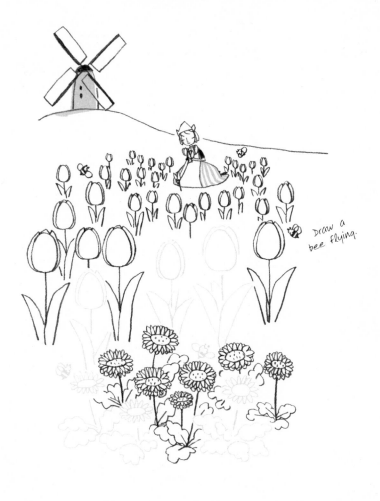

Draw a bee flying.

How to draw a honey bee:

roses

Roses were introduced into Europe from China and enchanted the aristocracy.

 Make divisions in a triangle.

 Draw the petals wrapped around each other in the shape of a shirt collar.

Add more outer petals in all three directions.

 Add even more petals, each one slightly different.

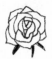 While looking at the whole flower, draw the petals at the back and the calyx.

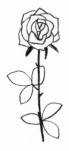

1. Draw the petals overlapping each other from the inside outwards.

2. Draw even more overlapping petals and the calyx.

3. Draw the stem, thorns, and leaves.

lilacs

Usually lilacs have four petals. It is said that finding a flower with five petals brings happiness.

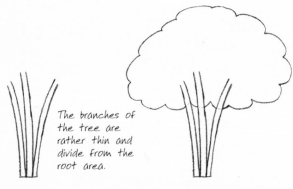

The branches of the tree are rather thin and divide from the root area.

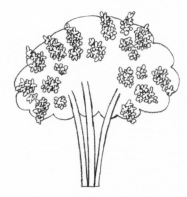

1. Draw the branches.

2. Draw the outline of all of the tree's leaves.

3. Draw groups of flowers toward the outside edge of the tree.

let's draw!

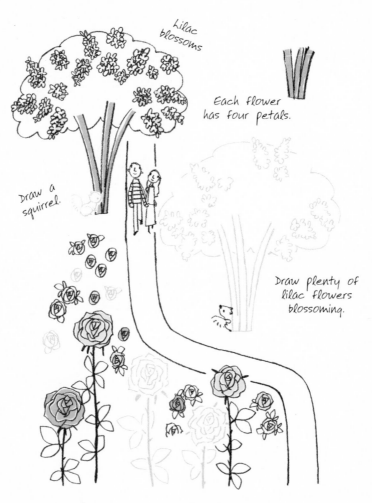

Lilac blossoms

Each flower has four petals.

Draw a squirrel.

Draw plenty of lilac flowers blossoming.

Draw cone-shaped groups of flowers.

ants

The ants that are busy working outside are the older
generation of ants. The younger ants work inside the nest.

 The tip of the ant's
nose is a little pointed.

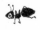 All of the legs grow
from the abdominal
part of the ant.

1. Draw the head
and antennae.

2. Draw the stomach
and the tapered bottom.

3. Draw the back legs.

dandelions

The english name "dandelion" originates from
a description of the leaves, which resemble a lion's teeth.

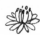

 Draw the first
layer of petals.

Draw the second
layer of petals partly
revealed between
these petals.

 The dandelion
clock is fluffy.

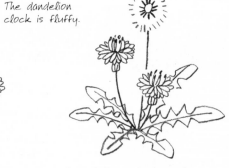

1. Draw the flower and the
husk (calyx) that holds it.

2. Various stems come
from one root.

3. Draw the jagged-
edge leaves.

let's draw!

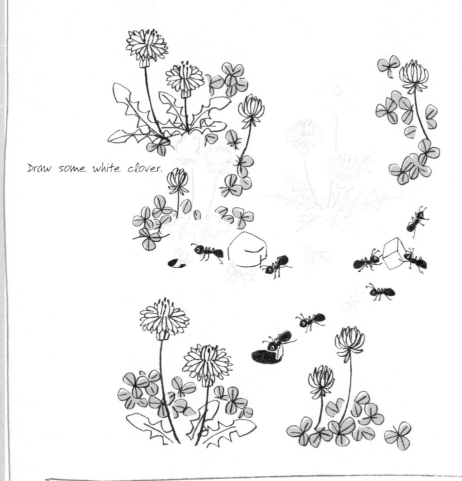

Draw some white clover.

How to draw white clover:

 Petals pointing up-wards are gathered in a group.

 This part is a little withered.

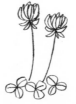

chinese lantern plant

The name for this plant in Japanese means inflating cheeks and comes from the image of someone playfully blowing into the fruit to make a sound.

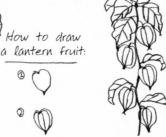

The edges of the leaves are wavy.

The fruit and leaves are attached to the pointed parts of the jagged stem.

How to draw a lantern fruit:

1. Draw a twisted stem.

2. Attach the fruit and leaves to the projected points of the twists.

3. Draw a leaf with each fruit.

praying mantis

After eating it is said to scrupulously clean its important forelegs.

Although they are actually compound eyes, we tend to draw pupils.

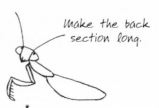

Make the back section long.

This is the way the legs have joints.

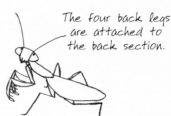

The four back legs are attached to the back section.

1. Draw the eyes, head, and feelers.

2. Draw the front section of the body and the foreleg in the foreground.

3. Draw the back legs and the foreleg on the other side.

let's draw!

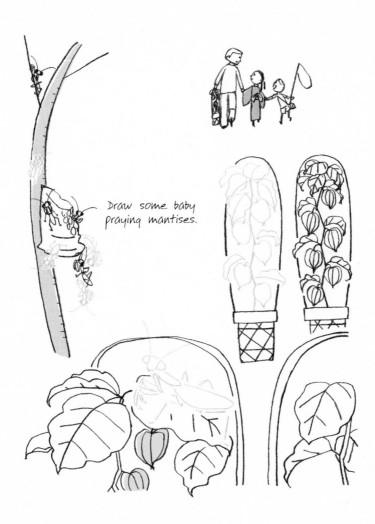

Draw some baby praying mantises.

water-lilies

Because the flower opens during the day and closes at night, it is called the sleeping lotus.

 Draw the petals in the front.

 In between these add the petals in the back peeping through.

 Draw the calyx.

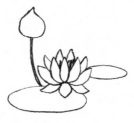

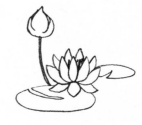

1. Draw the petals in order from the center outwards.

2. Draw the leaves floating on the water and a flower bud.

3. Add the split in the leaves and the lines showing the unopened petals.

ornamental carp

According to legend, the carp that ascends the waterfall actually becomes the waterfall, and this is how it became a symbol of success.

The top lip and whiskers are its special features.

The stomach is flat and the back is a little rounded.

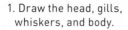

1. Draw the head, gills, whiskers, and body.

2. Draw the fins.

3. Add a pretty pattern.

let's draw!

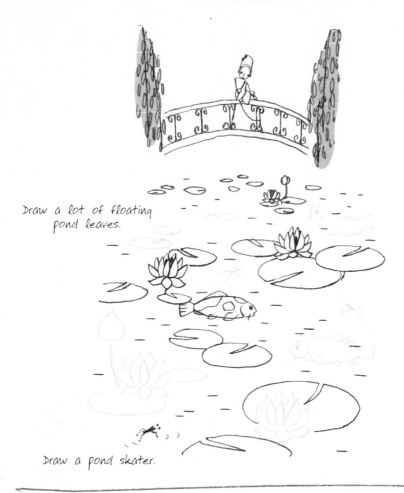

Draw a lot of floating pond leaves.

Draw a pond skater.

How to draw a pond skater:

Draw an X sign.

Ripples in the water signify that it is a pond skater.

hibiscus

This is not an herbaceous plant; it belongs to the tree family. Flowers bloom at the end of the newly grown branches.

The petals open from near the back edge of the petals in the front.

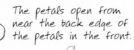

The leaves are on the left and right sides.

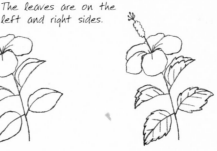

The stamen and pistil stretch upwards.

1. Draw the petals at the front, then those at the back, and the stamen and pistil.

2. Draw the trunk and the outline of the leaves.

3. Draw the veins and the jagged edges of the leaves.

palm trees

The fruit of the palm tree, the coconut, contains 1 quart (1 liter) of water and delicious flesh.

Consider the direction of the wind.

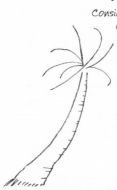

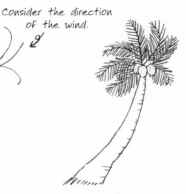

The roots are a little exposed.

1. Draw the trunk of the tree.

2. Draw lines on the tree and the stalks that are in the middle of the leaves.

3. Draw the leaves and the coconuts.

let's draw!

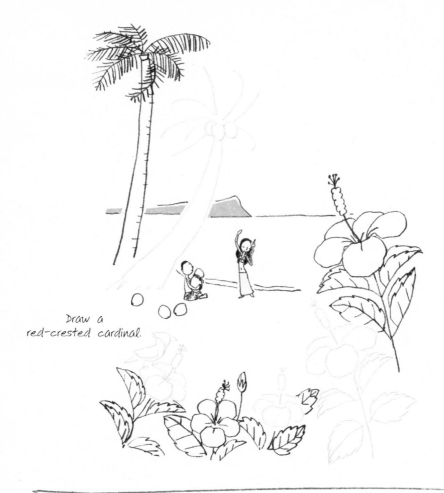

Draw a
red-crested cardinal.

How to draw a red-crested cardinal:

 The end of the
beak is a little
curved.

frogs

Frogs can stick firmly anywhere because they have sucker pads on the ends of their hands and feet.

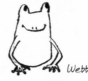

The eyes and mouth protrude.

Draw the bow-shaped arms and legs.

A little wide around the waist

Webbed feet

1. Draw the eyes, mouth, and body.

2. Draw the hands.

3. Add the back legs.

fireflies

They glow without producing heat—more effective than electricity.

Note the difference between the heike firefly and genji firefly.

1. Draw the head and wings.

2. Color the wings black and draw the feelers and the pattern on the body.

3. Draw the legs and the light glowing from the backside.

let's draw!

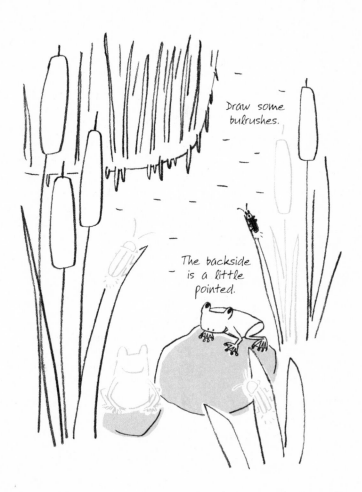

Draw some bulrushes.

The backside is a little pointed.

gingko trees

The fruit of the gingko tree (gingko nuts) are effective to help stop coughs, and the wood from the tree is used to make high quality wooden chopping boards and foundations.

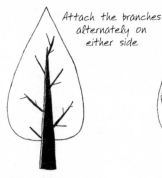

Attach the branches alternately on either side

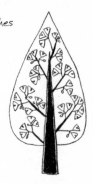

1. Draw the trunk.

2. Draw the branches and the overall outline of the tree's leaves.

3. Draw the leaves and it is finished!

pampas grass

Used as material to make thatched roofs, watch out for the serrated edges of the leaves!

Draw the fluffy parts.

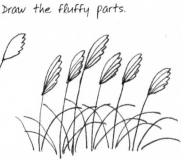

1. Decide the direction of the wind before drawing the stalks.

2. Draw the outline of the plumes fluttering in the wind.

3. Draw defining lines in each plume one by one and the leaves.

let's draw!

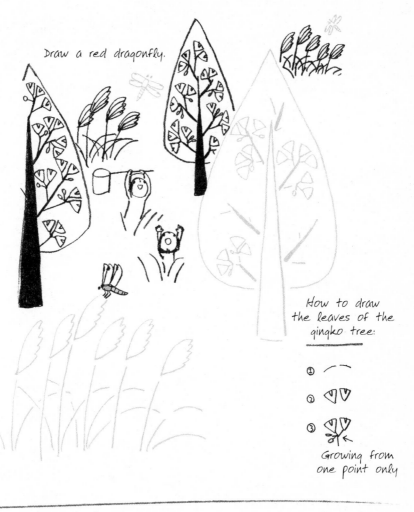

Draw a red dragonfly.

How to draw the leaves of the gingko tree:

① ⌒

② ▽▽

③ ▽▽

Growing from one point only

How to draw a red dragonfly:

 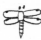

There is a pattern on the tips of the wings.

flower arrangement

You can create various arrangements of plants and flowers according to seasonal events. Try to experience the real feeling of handling the flowers and make some beautiful bouquets!

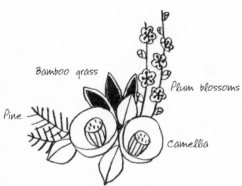

Bamboo grass

Plum blossoms

Pine

Camellia

New Year's

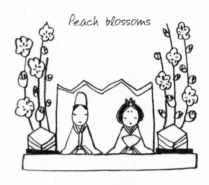

Peach blossoms

The Doll's Festival

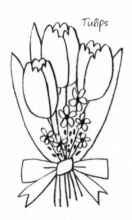

Tulips

First day of school

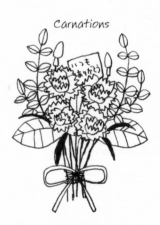

Carnations

Mother's Day

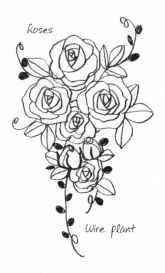

Roses

Wire plant

Wedding bouquet

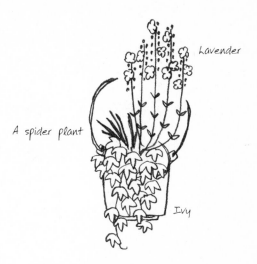

Lavender

A spider plant

Ivy

A variety of plants in one pot

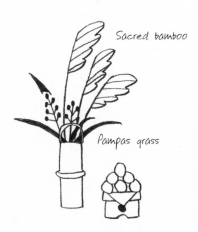

Sacred bamboo

Pampas grass

Moon viewing

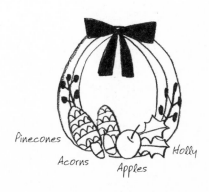

Pinecones

Acorns

Apples

Holly

Christmas

apples

A delicious apple is red from top to bottom and has a pleasant fragrance.

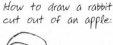

How to draw a rabbit
cut out of an apple:

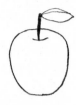

1. Draw the round
outline of an apple.

2. Draw the indented
part on the top and
the calyx.

Draw a rabbit shape
made from apple.

bananas

Just like red wine and green tea, bananas contain plenty of polyphenol.

The area around the
edges of the tips of
the bananas tends to
bruise easily.

While drawing the tips
of the bananas, pay
attention to the
direction the bunch
of bananas is facing.

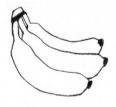

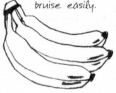

1. Draw the top tips
and the base to the
banana.

2. Draw the outline of
the bunch of bananas.

3. Draw the edges to the
bunch of bananas and the
spots that have ripened
and turned black.

let's draw!

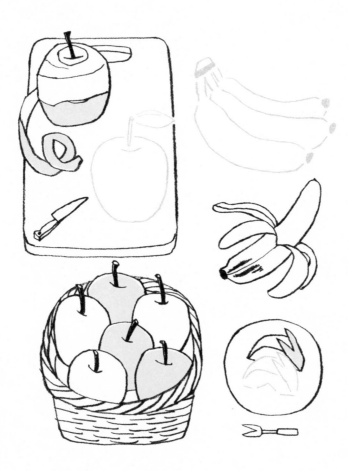

a pineapple

Asian fried rice ("chahan") contains pineapple and is delicious!

The end of the pineapple is a little tapered.

Draw curved shapes alternately.

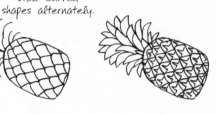

Draw the pineapple from the base.

1. Draw the outline of the fruit and the pattern on the surface that resembles a pine-cone.

2. Draw the guidelines of the leaves.

3. Add thickness to the leaves and draw the pointed pattern.

a watermelon

The seeds are arranged in the striped sections. Avoid these parts when slicing the watermelon.

Use the guidelines as a base and draw stripes.

 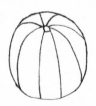 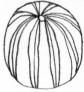 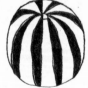

1. Draw the overall outline and the calyx.

2. Draw the guidelines for the stripes in a radial shape.

3. Draw some rough stripes.

4. Color the stripes black.

let's draw!

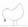

carrots

The word "carrot" originates from the word "carotene,"
which helps to ease eye fatigue and stave off aging.

It is sprouting
in a wild way.

The grooves are
all arranged in one line.

1. Draw the outline of the vegetable and the base to which the stalks and leaves are attached.

2. Draw the stalks and leaves.

3. Draw the grooved lines on the carrot and a wavy line around the leaves.

pumpkin

A long time ago, people used to preserve the pumpkins they dug up in summer and then eat them in the winter to get their nutrition.

Draw the bumps
on the top and
bottom.

Draw the ridges in
line with the bumps.

1. Draw the calyx.

2. Draw the outline with an image of a slightly square circle.

3. Draw the solid ridges lined up with the bumps.

let's draw!

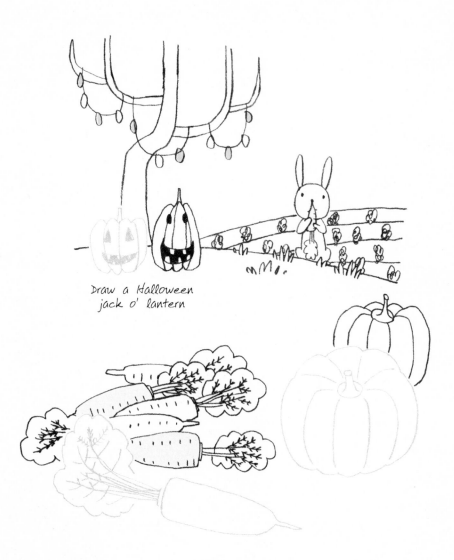

Draw a Halloween
jack o' lantern

illustrations on stationery

If you spend some enjoyable time creating special illustrations and add them to letters or cards, you can be sure that the recipients will definitely feel great pleasure as well.

Arranged in lines. Joined up. Repeated. Whatever method you follow, if you continue drawing the flowers and insects, it turns into a pretty design before you know it. Plants and insects are motifs that are often used. Why don't you try decorating the letters and cards you casually send with designs that you have created?

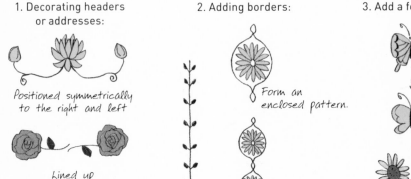

1. Decorating headers or addresses:

Positioned symmetrically to the right and left

Lined up side by side

Joined

2. Adding borders:

Repetition

Form an enclosed pattern.

Repeat this pattern.

3. Add a focal point.

Omit some parts.

You don't have to draw everything down to the stem, as well. Just draw part of the picture and focus on one point.

4. Background patterns

Snow

Rain

Starry sky

5. Letters and Cards with Designs

Patterns for letter paper should be created in a color that does not get in the way of the writing.

Add an elegant effect to cards.

A small button-sized design as a seal on the envelope

Add a flower or plant design to notepaper and convey a sense of the season.

about the author

Sachiko Umoto graduated with a degree in oil painting from Tama Art University in Tokyo, Japan. In addition to her work as an illustrator, she also produces animation for USAGI·OU Inc. She is the author of *Illustration School: Let's Draw Plants* and *Small Creatures and Illustration School: Let's Draw Cute Animals* (both originally published in Japan by BNN, Inc.). She dearly loves dogs and Hawaii.

 Visit her online at http://umotosachiko.com.